reflections

Poems

and
Sumi e

Copyrighted Material

Copyright © 2016 Barbara Schmitz
Illustrators Copyright © 2016 Barbara Schmitz

ISBN: 978-1523414222

ISBN: 1523414227

All rights reserved. No part of this book may be reproduced or transmitted in any
form or by any means, electronic or mechanical, including photocopying, recording, or by any information storage or retrieval system, without permission in writing from the copyright owner.

This book was printed in the United States of America.

Published by: Barbara Schmitz

Author: Barbara Schmitz    Illustrator: Barbara Schmitz

*Dedication*

*Reflections is dedicated to my daughter
Suzette with my love*

# Preface

"Reflections" is a collection of original Chinese brush paintings, and poems. All were created by Barbara Schmitz over a period of years. Barbara is an award-winning artist who lives on the Eastern Shore of Virginia and in Stuart, Florida. She has written throughout her life, even winning the Creative Writer's Award at her high school graduation. She began painting when she retired, and has been a student of oriental art for over a decade. She has published "Plein Air France - A Journey", 2010; "Potpourri", 2012: "Maine Impressions", 2013; and "Magic at the Four Acre Woods", 2013. She participated in the collection "Faerie Yarns" complied by Betty Ross and Grace Wakefield in 2012. All of her books contain her artwork. The themes of her writings in "Reflections" are the enjoyment of the natural world, and living on the earth gently. Her hope is to bring to the readers both peace and pleasure in their day.

Spring Tanakas

*Unity*

Creature of the earth
Watching others make their way
Living, breathing here
Moving, flowing and being
All a force of one

*Strength*

Against chill spring wind
The cherry blossom opens,
Gives beauty and lasts
Its few swift appointed days,
Leaving an eternal thought

May 18, 2009

## An Encounter With Beauty

Celebrate the beauty
Let the wonder in.
The awe that rises in you,
Let the joy begin.
Feel, while breathing deeply
The air is clean and spare.
Watch, as gently, sweetly,
It leads and takes you there.
Let it overcome you,
Leave yourself behind,
As now the beauty in you,
Becomes one with earth and mind.

July, 2012

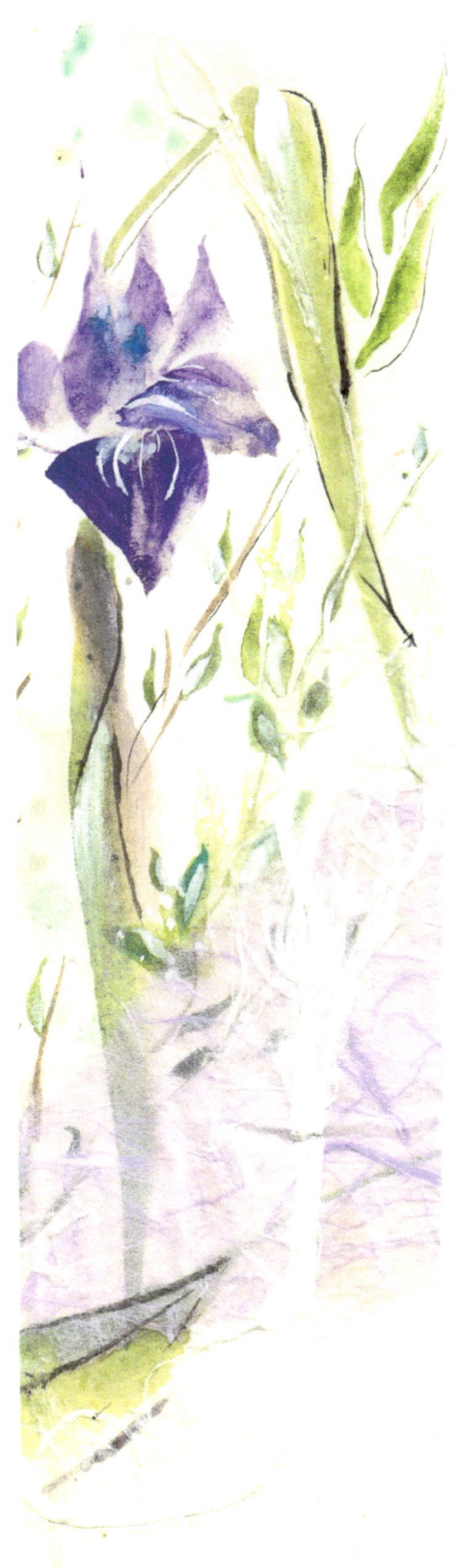

## Garden Companions

On a silvery soft leaf of lamb's ear
In diamonds of fresh morning dew
He holds himself silently waiting
For the glimpse of a faerie or two

His tiny form melds with the lamb's ear
As he quietly rests there inside
The plant's leafy story above him
While a faerie face watches with pride

For she looks in dew dropped mornings
While the garden's sweet magic unfolds
And her eyes set upon that dear lamb's ear
With the tree frog inside to behold

So the tree frog said to the faerie,
"It's your face that I've waited to see"
She replied, "I'm charmed to find you there waiting,
Our acquaintance was destined to be"

On occasion she spies him again there
As he hides underneath a soft leaf
Then they greet one another once more there
And enjoy a time both sweet and brief

She tells him a secret or two there
In the garden where each has a place
He watches her quietly, safely
Companions in this magical place

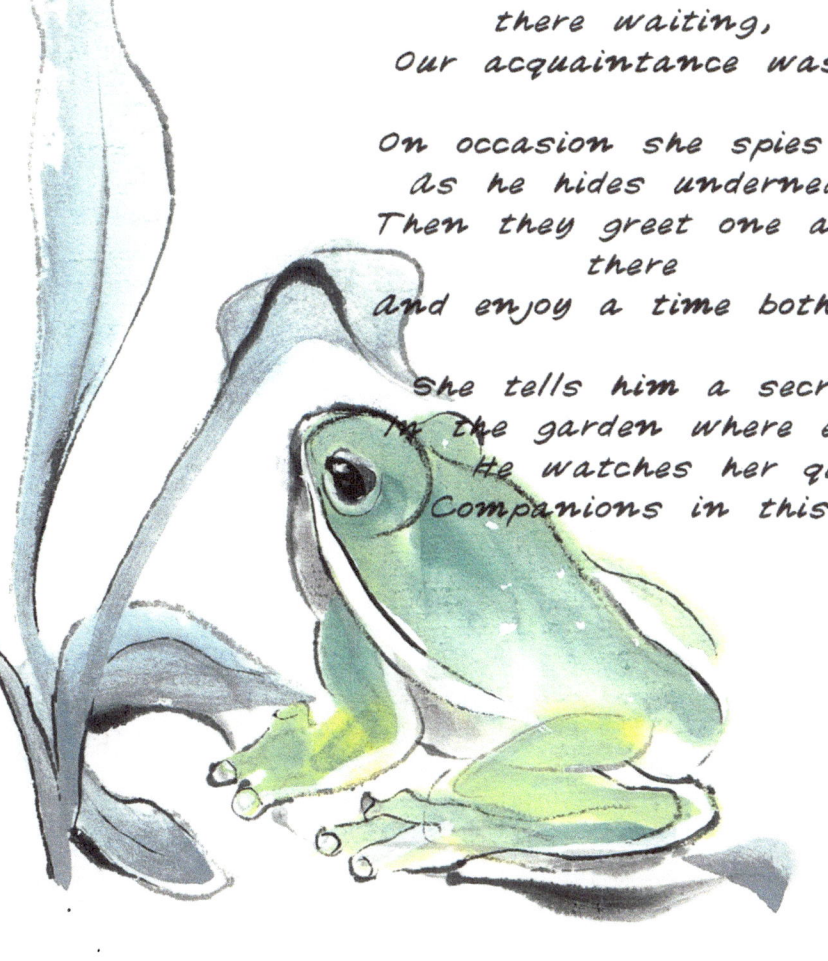

April 15, 2013

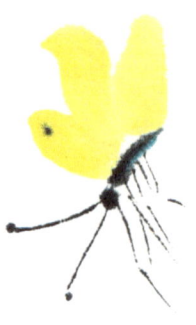
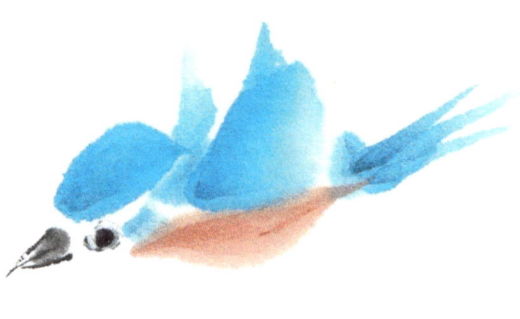

## I WISH

I wish I were a dragonfly
I'd fly with glistening wings
And rest upon some lily pads
Mesmerized by water drop rings

I wish I were a butterfly
I'd nectar on flowers until
Fluttering in a sun filled garden
I'd drink even more than my fill

I wish I were a big golden spider
I'd spin a fabulous web
Where I'd store myriads of mosquitoes
To eat when I went to my bed

I wish I were a rabbit
Under the fence I would go
And eat up all the good veggies
The farmer who lived there could grow

I wish I were a bluebird
I'd flash my wings to the sky
And sit high upon a garden pole
Where fat grubs for my lunch I would spy

I wish I were a little wren
Where perched on a fence post I'd sing
A song so loud, free and joyous
That the woodland in echo would ring

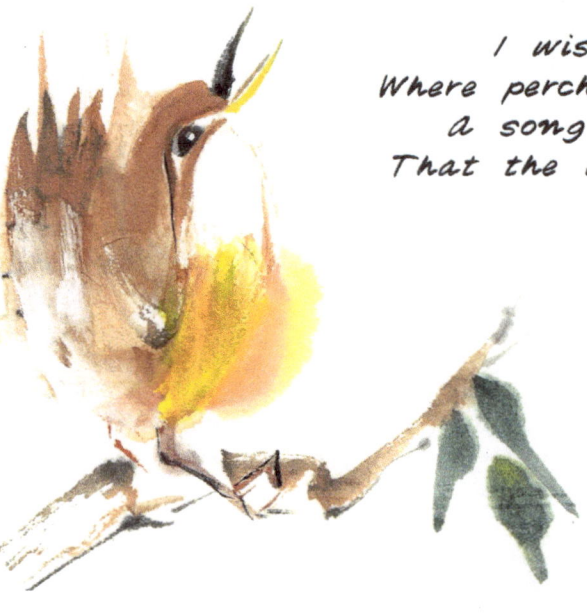

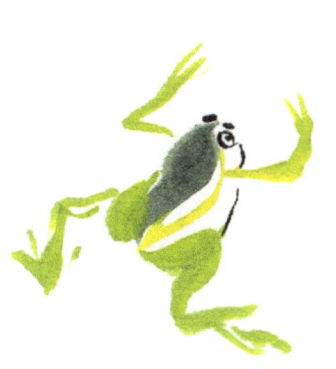
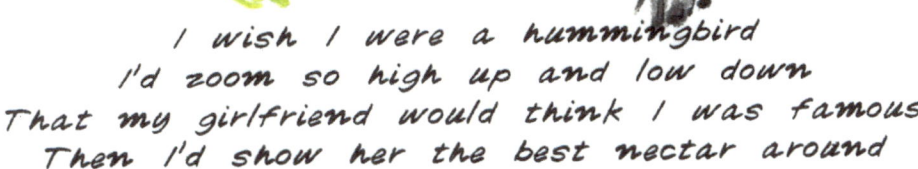

I wish I were a hummingbird
I'd zoom so high up and low down
That my girlfriend would think I was famous
Then I'd show her the best nectar around

I wish I were a red tailed hawk
I'd soar to the clouds in the sky
And watch the creatures below me
Choosing their places to hide

I wish I were an elegant pond fish
My orange and white body I'd swirl
I would swim underneath lily shadows
And give snacking on pond snails a whirl

I wish I were a blue tailed skink
I'd live in the back yard shed
And surprise the humans who opened the door
For their tools when I'd scare them instead

I wish I were a black rat snake
I would warm and bask in the sun
And hide in the greens of a garden
To eat mice, rats and voles for the fun

I wish I were a green tree frog
I'd stick to and climb a porch wall
And eat juicy bugs by the nightlight
Then sing loudly a Thank You to all

Consider the lives of these creatures
(How delightful if it could be)
I've decided that now I'm contented
To keep on keeping on being me

July 24, 2014

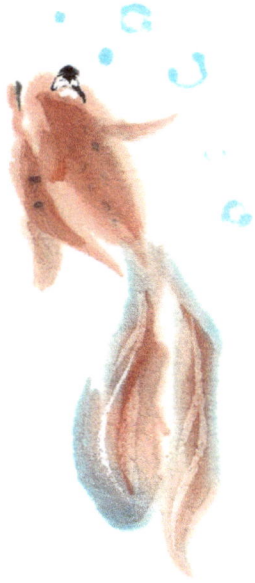
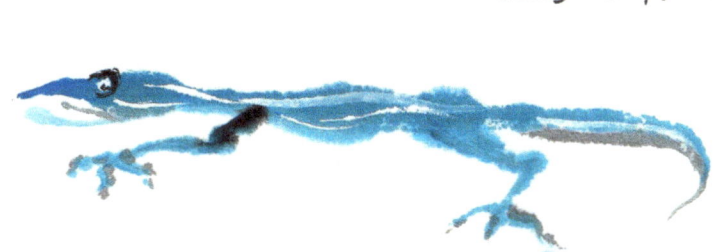

# What IS
## Haikus

Look into the day
Witness the space and listen
It tells of what is

Warm sun envelops
Quiet invades my being
Calms my rapid heart

Black Eyed Susan gold
Brilliant yellow enticing
Life force for the bees

Darner dragonfly
He's fast and filled with purpose
As I watchful, rest

Sunflower tower
Powerful green and growing
Feasting for later

Grasses sway gently
Breezes hold a cooler air
A butterfly lift

Sweet honeysuckle
Trumpet shaped and inviting
Hummingbird accepts

Moving water sounds
Calling us all to listen
Essential music

Garden life teeming
From those with wings to crawlers
Living their purpose

All is in balance
On a summer afternoon
World in a garden

August, 2015

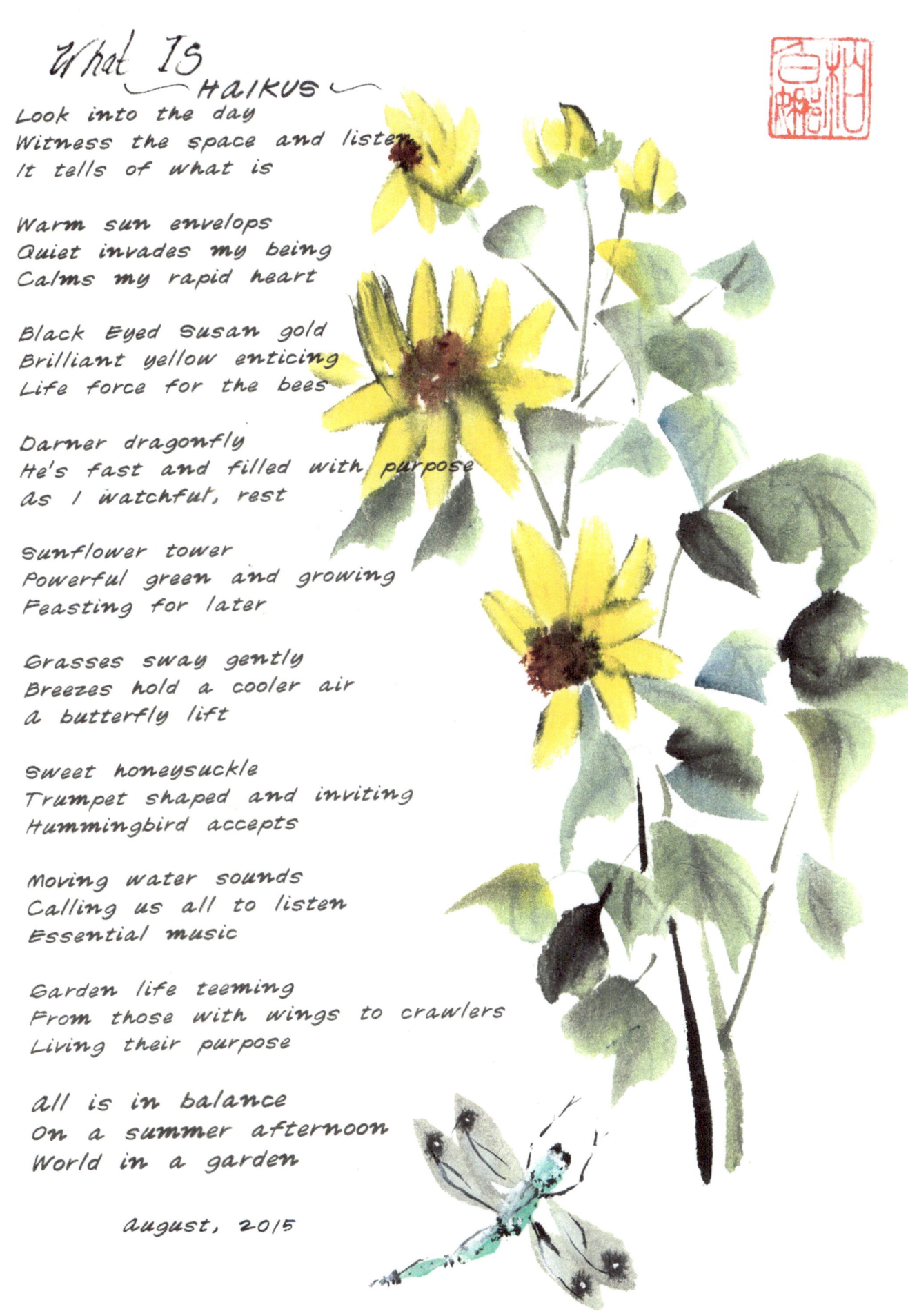

# Sea Faeries

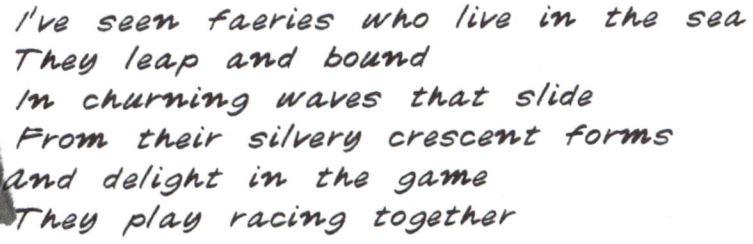

I've seen faeries who live in the sea
They leap and bound
In churning waves that slide
From their silvery crescent forms
And delight in the game
They play racing together
Toward the vast open water

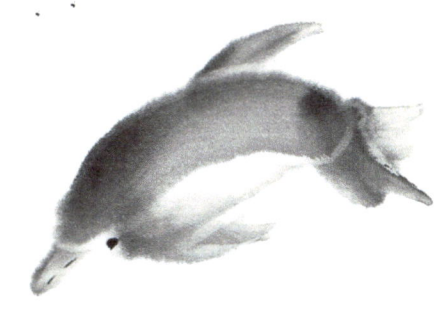

I've seen faeries who live in the sea
They love breaking through
Flying low over the surface
Spreading their glistening wings
Speeding faster than the ship behind
Plunging into the green salty water
Only to reappear and fly again

I've seen faeries who live in the sea
Transparent jelly circles
Body parts on show for all to see
Floating and moving in lazy direction
Varying rounds in shallow layers
Caressing the water as they travel on

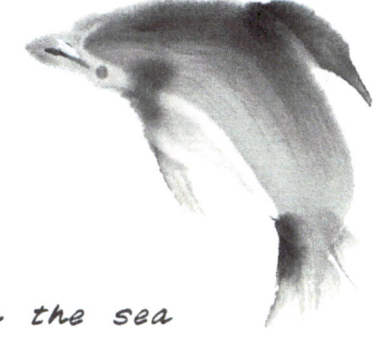

I've seen faeries who live in the sea
Small long pipes swimming together
Fussing with curiosity around the docks
Sampling tidbits of this and that
Big eyes not missing the myriads
Of treats available as they undulate
In the shallows

Thinking of faeries I've seen in the sea
Those who remain are a question
Amazing shapes that move in the flow
Colors reflecting the presence of light
Changing life forms existing together
Multiple creatures in the world of the sea
The stuff faerie daydreams are made of

October, 25, 2015

# SHADES OF GREY
## Tanakas

**Apparently Grey**

Clear and transparent
The primary colors sing
But mixed together
Varied shades of grey appear
A soft enhancing surprise

**Reflections**

Low sunshine today
But when it's grey and misty
It's better to see
Silvered mirrors cling to leaves
Just right for reflecting

**Buddha Sadness**

Living with sadness
Greys down daily feeling tone
But then to practice
Attending to simple tasks
Brings pleasure and contentment

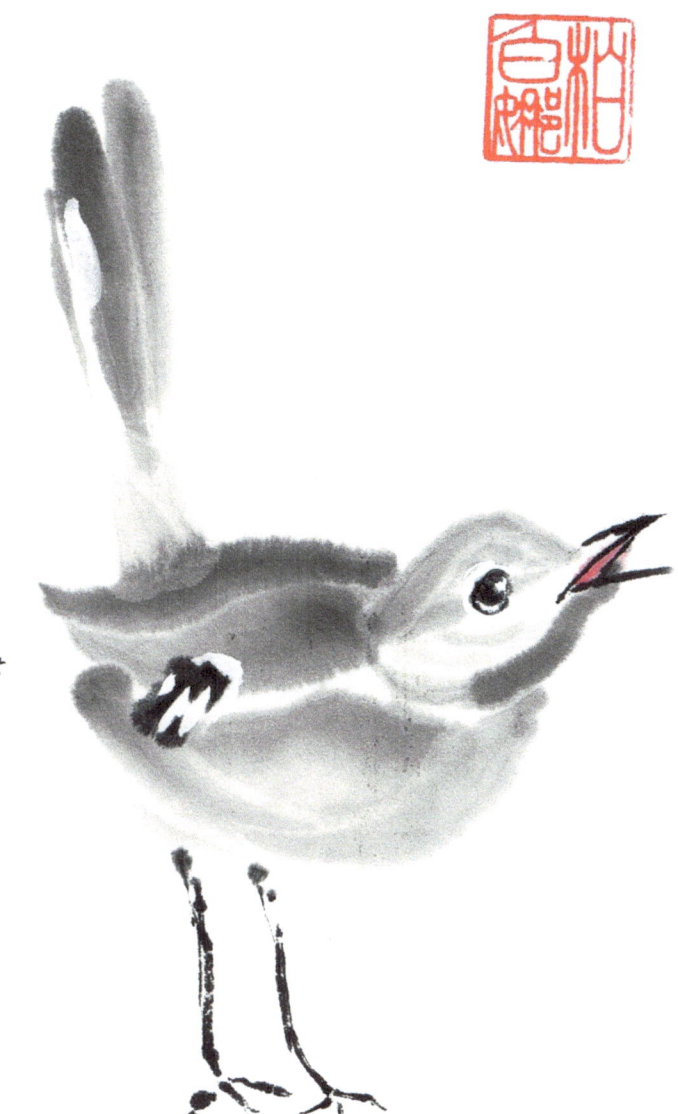

**The Mockingbird**

The grey and white bird
His color ordinary
Yet on his high perch
He rules the whole neighborhood
With his full throated concert

**Ink**

Pressed and pushed in rounds
The ink stick grinds on the stone
Ink now grey and black
Ready for wet bamboo brush
And the dreams of an artist

June, 2015

## RIGHT AND TRUE

I met myself the other day.
While turning around,
I was caught looking unexpectedly
Inside another time.
Yet here I was again,
The themes congruent,
Faithfull to the early days,
And feeling right and true.
Surprised at the intensity of the moment,
I thought these were merely interests,
Which would pass, or evolve and change.
No, I knew then with a sense of inner trust,
That these deeper lasting strands
Are weaving through my life.

Love of the earth and the natural world.
A search for simplicity and essence.
Appreciation of the music of language, of beauty
and grace.

May 13, 2010

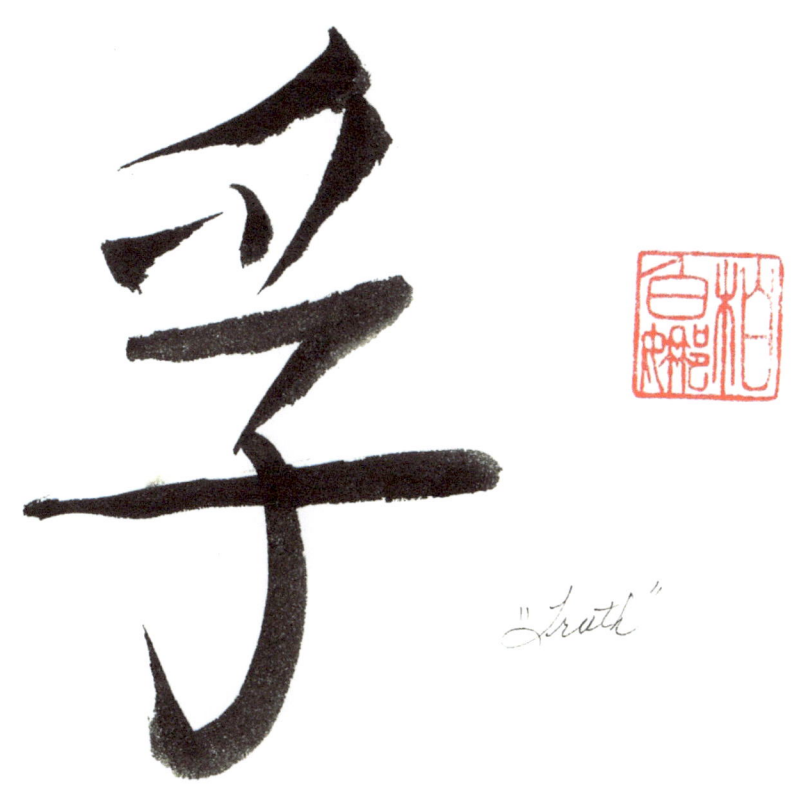

"Truth"

## LOST AND FOUND

Within myself a sense of land,
A sense of place and peace.
The sway of trees and song of green,
My eyes move over grass.

Goodby to marsh and waterland,
Goodby to wading birds.
To saltmarsh, floods and heather foam,
I'll come to see you soon.

But I'll go back to land again,
Where heart and mate converge.
A dream of padding through the house,
And he is somewhere near.

He's gardening, carving, calling out,
And I'll respond to him,
And paint and plant the flowers in
And feel at home again.

2003

## SISTERS

How I love my women friends,
A covenant of sisters who gather around me,
Each separate and unique,
Surprising me with talents and quirks of personality,
Giving off shots of light in all directions,
Who share in trust and intimacy,
The delights and sorrows of their days.

　　　　　　　Barbara in Atlantic, Va.
　　　　　　　May 11, 2010

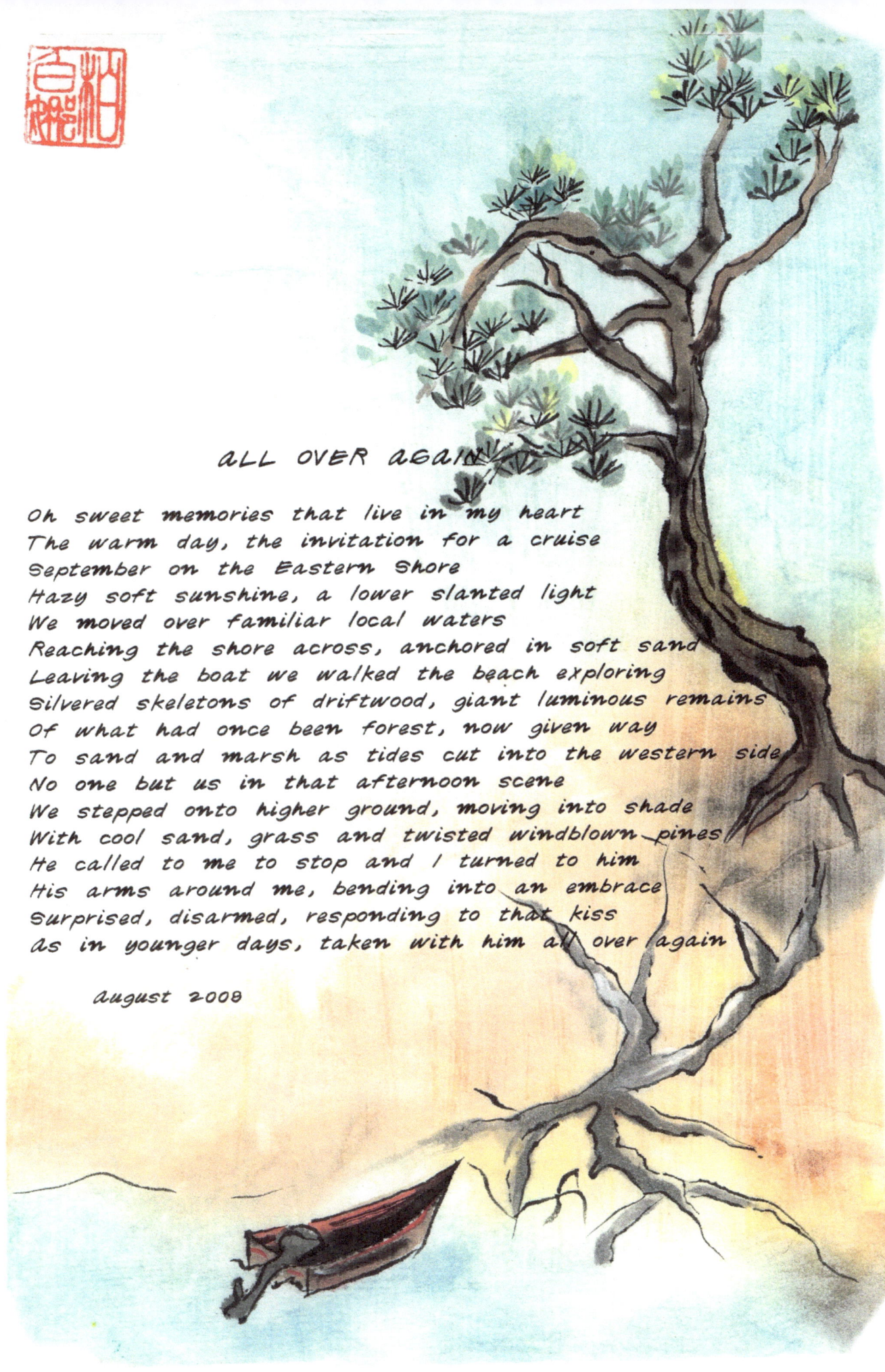

## ALL OVER AGAIN

Oh sweet memories that live in my heart
The warm day, the invitation for a cruise
September on the Eastern Shore
Hazy soft sunshine, a lower slanted light
We moved over familiar local waters
Reaching the shore across, anchored in soft sand
Leaving the boat we walked the beach exploring
Silvered skeletons of driftwood, giant luminous remains
Of what had once been forest, now given way
To sand and marsh as tides cut into the western side
No one but us in that afternoon scene
We stepped onto higher ground, moving into shade
With cool sand, grass and twisted windblown pines
He called to me to stop and I turned to him
His arms around me, bending into an embrace
Surprised, disarmed, responding to that kiss
As in younger days, taken with him all over again

August 2008

# STILL LIFE

## Mud Men
Placed close to my chair
Mud men so finely detailed
Small Asian mystery
Dad's spirit lingers nearby
Their allure still beguiling

## Stoneware Jug
Tall grey stoneware jug
Handmade on a potter's wheel
Blue striped, waiting there
My grandmother's memory
Among the jeweled jars of fruit

## Imari Platter
Profuse reds and blues
Bold imari platter stands
Rich reminiscence
Hearing Clara's voice once more
Weaving its family tale

## Luster Teapot
Luster teapot glows
Sweetly painted cottage scene
Offered to a friend
Fun, generous, and loving
Jeanne's nature surrounds the piece

Nov. 2013

# CHANGE
## Five Fall Tanakas

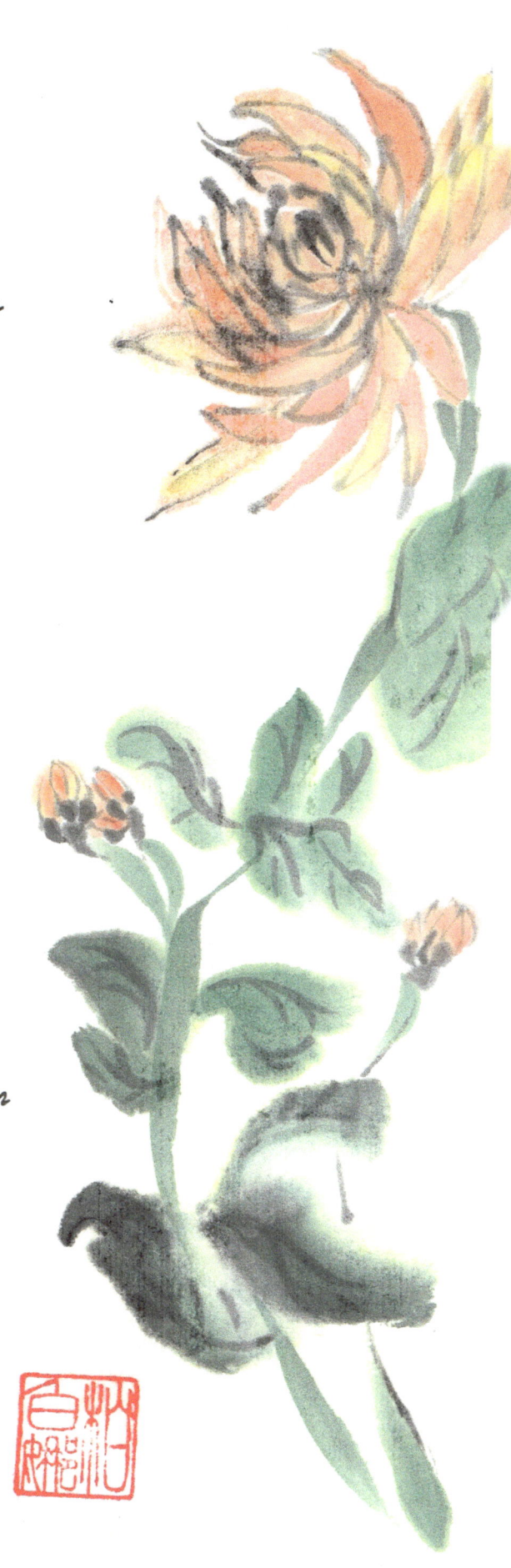

### Flown
It's happened again
We looked for them this morning
Our coffee in hand
They've flown, not one to be seen
Hummingbirds, gone for winter.

### Overgrown
My frowsy garden
Rusty blossoms touch the ground
Yellow musty leaves
Stems give way under the weight
Overgrown, waiting for change.

### Berries
Berries everywhere
No longer flowers, but fruit
We creatures enjoy
Seduced by their bright colors
Rose hips, crabapples, hollies.

### Autumn Storm
Wind and rain arrived
And whipped spartina grasses
Into twisted whorls
As muddy serpentine streams
Of salt water seeped through them

### Darkness
Dusk is early now
Sun glare, sunset and darkness
In quick succession
Bright Jupiter in the east
The bullfrogs sing about it.

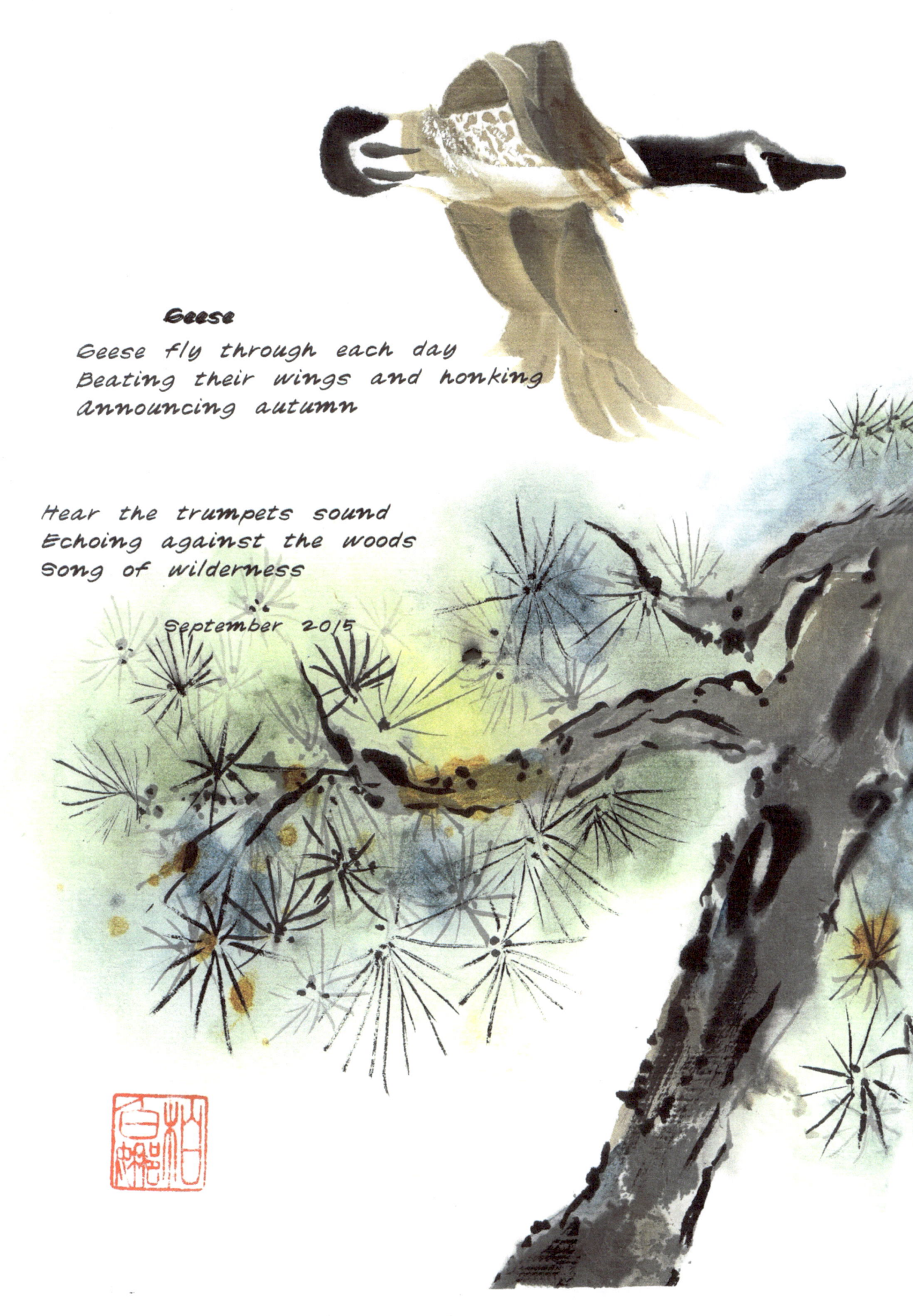

### Geese

Geese fly through each day
Beating their wings and honking
Announcing autumn

Hear the trumpets sound
Echoing against the woods
Song of wilderness

September 2015

# I REMEMBER LEAVES

I remember leaves
Driving through Berks County's blazing hills
Excitment rising in my heart as I'm
Coming home again

I remember leaves
Raking piles and covering the kids
Cool air, warm jackets, red cheeks, wet noses
Laughing there together

I remember leaves
Leaves hanging onto pin oaks, bleached out brown
Rustling stiffly in the wind oh I'm
Willing them to fall

I remember leaves
Leaves nestling at the rock wall, wet and dark
Chilly fingers gently push aside, and I
Find the daffodils

October, 2002

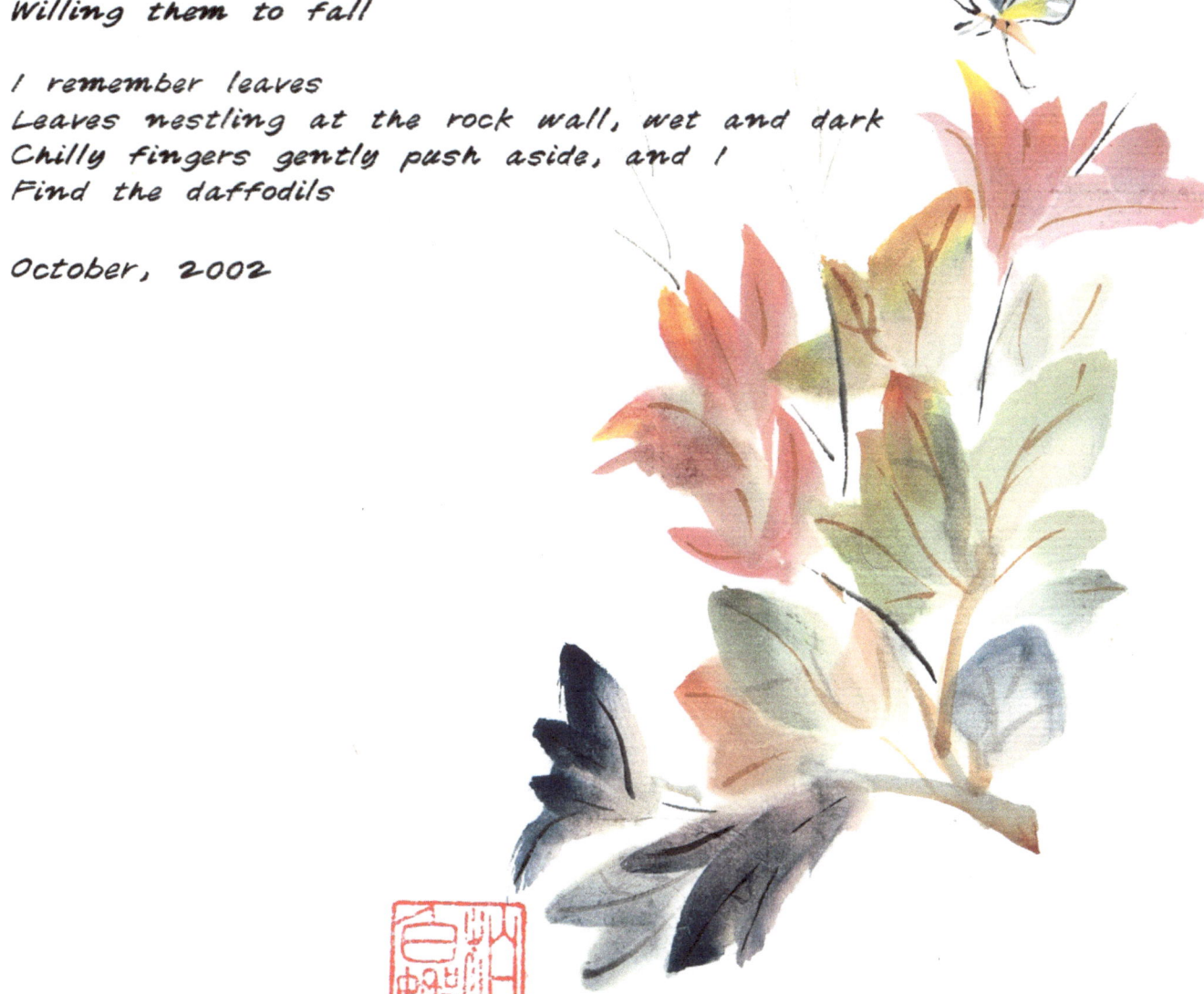

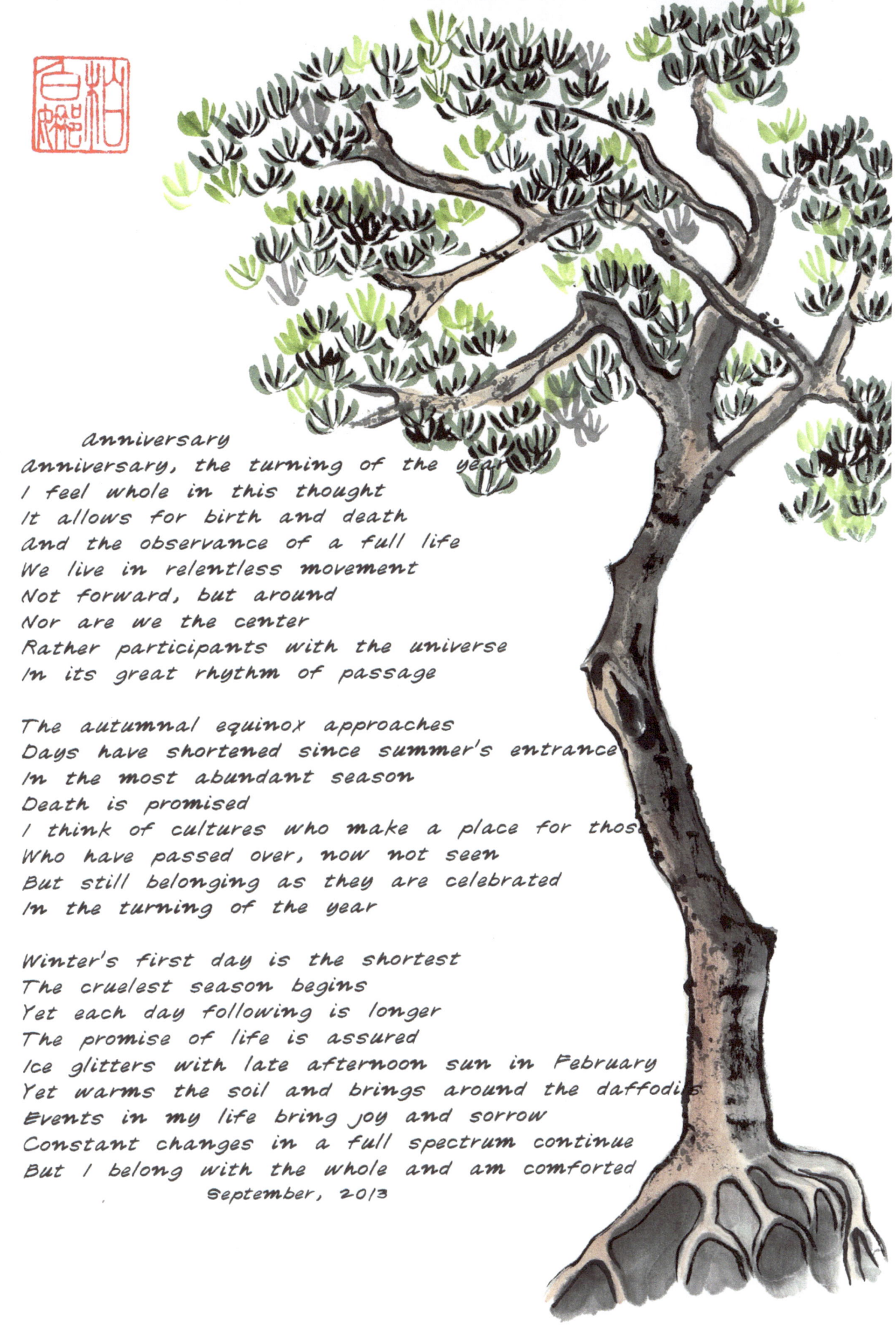

Anniversary

Anniversary, the turning of the year
I feel whole in this thought
It allows for birth and death
And the observance of a full life
We live in relentless movement
Not forward, but around
Nor are we the center
Rather participants with the universe
In its great rhythm of passage

The autumnal equinox approaches
Days have shortened since summer's entrance
In the most abundant season
Death is promised
I think of cultures who make a place for those
Who have passed over, now not seen
But still belonging as they are celebrated
In the turning of the year

Winter's first day is the shortest
The cruelest season begins
Yet each day following is longer
The promise of life is assured
Ice glitters with late afternoon sun in February
Yet warms the soil and brings around the daffodils
Events in my life bring joy and sorrow
Constant changes in a full spectrum continue
But I belong with the whole and am comforted

September, 2013

TO BE

This is my challenge
To quietly observe my surroundings
In holistic awareness
To breathe fully into and out of my body
With deep healing breath
To be in this moment
Eperiencing
To allow sensation as one with earth
Being
To be absorbed by life energy
Becoming one with all

July 2013

"Chi - Life Energy"

## The Scarab's Tale

There among the roses
The beetle glistens green
He glows with summer sunshine
He's living in my garden
And waits there to be seen

I wonder at his colors
In iridescent gleam
His size is quite impressive
I startle when I meet him
And remember what he means

He promises eternal life
Within another way
Of things unknown that come to be
Of forces still continuing
The renewal of each day

Today I'm meant to meet him
And remember the scarab's tale
In the waning sun of an old day
There's a promise of a new one
Where life's synergy prevails

8/21/2015

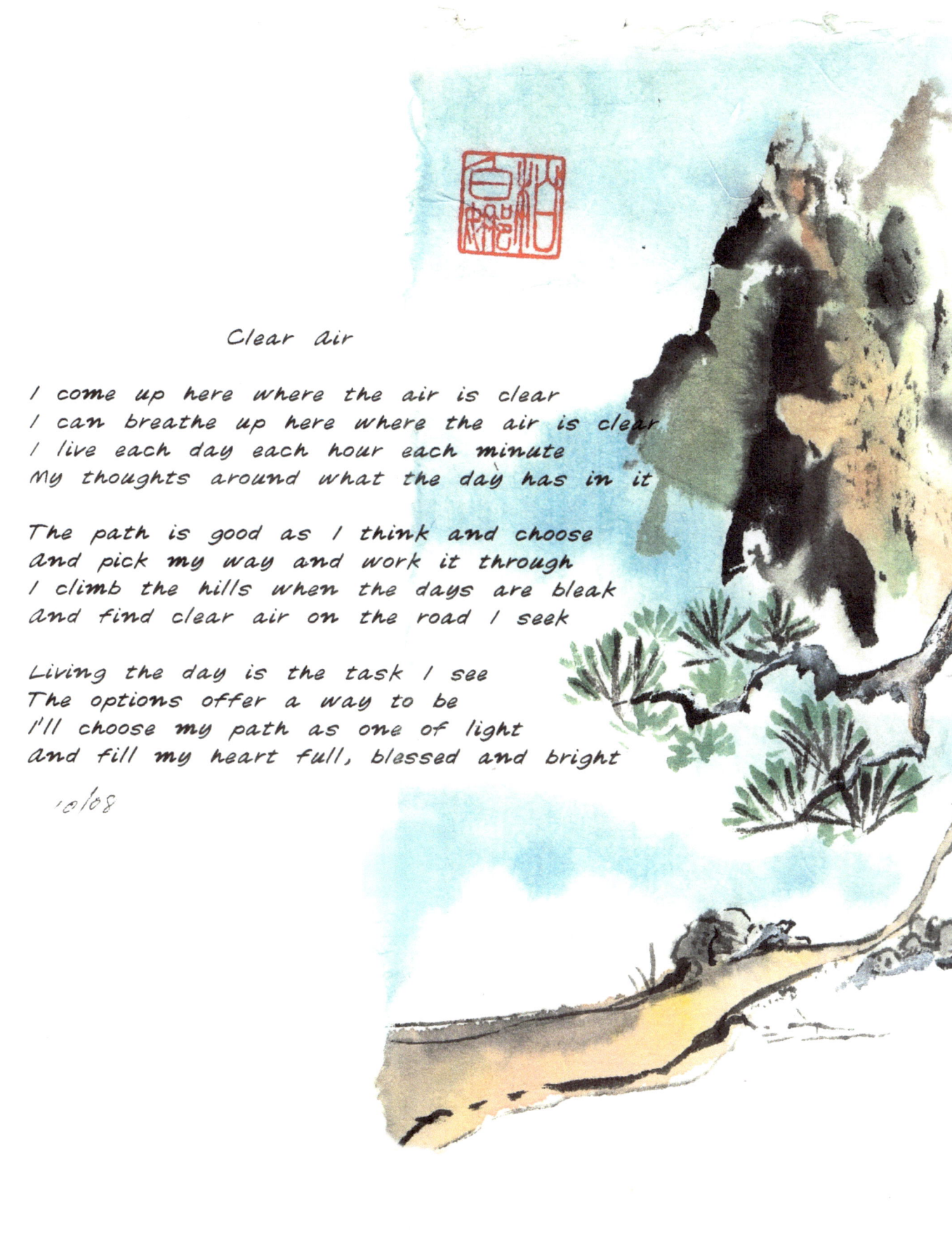

*Clear Air*

I come up here where the air is clear
I can breathe up here where the air is clear
I live each day each hour each minute
My thoughts around what the day has in it

The path is good as I think and choose
And pick my way and work it through
I climb the hills when the days are bleak
And find clear air on the road I seek

Living the day is the task I see
The options offer a way to be
I'll choose my path as one of light
And fill my heart full, blessed and bright

10/08

~The End~